FIFTY GOLDEN YEARS

FIFTY GOLDEN YEARS

Incidents in the Queen's Reign

Mrs. Craik
THE AUTHOR OF
"JOHN HALIFAX, GENTLEMAN"

ILLUSTRATED BY
ARTHUR AND HARRY PAYNE, BERTHA MAGUIRE
AND F. SARGENT

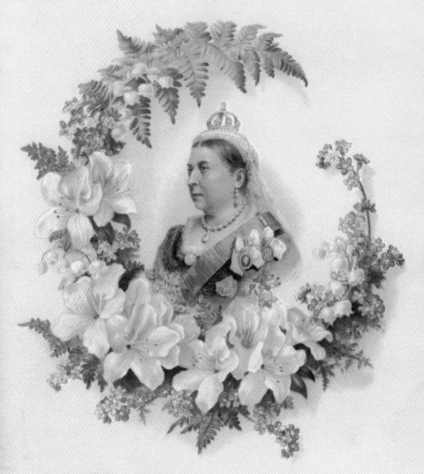

Her Most Gracious Majesty

Queen Victoria

Queen of Great Britain & Ireland and Empress of India.

Published by English Heritage, NMRC, Kemble Drive,
Swindon SN2 2GZ
www.english-heritage.org.uk

First published by English Heritage 2006
© English Heritage 2006

ISBN-10 1 85074 991 4
ISBN-13 978 185074 991 2
Product code 51174

Text selected and abridged by Elizabeth Drury
Designed by Eric Drewery
Printed in Hong Kong

DEDICATED

BY SPECIAL PERMISSION

TO

HER MOST GRACIOUS MAJESTY

The Queen

FOREWORD

'FIFTY Golden Years' appeared in 1887 to mark the first fifty years of Queen Victoria's reign. It was one of the numerous souvenirs produced for the Golden Jubilee. Glass and ceramic items, including teapots and mirrors, were manufactured in large quantities, as well as machine-woven silk pictures and commemorative handkerchiefs.

The publisher of 'Fifty Golden Years', Raphael Tuck & Sons, was a firm specialising in greeting cards, embossed scraps and Sunday School pictures, and the appointed supplier of the royal Christmas cards. Mrs Craik, famous at that time as the author of the novel 'John Halifax, Gentleman', wrote the dedicatory poem and the reminiscences of incidents in the Queen's reign that accompany the colourful chromolithograph illustrations. The flavour of the book is as 'Victorian' as can be.

The pictures in this edition are reproduced from the original illustrations by Arthur and Harry Payne, Bertha Maguire and F. Sargent, and the words taken from Mrs Craik's original text.

CONTENTS

TO THE QUEEN

Dedicatory Verses

I Sang Thee in my childish days,
 Girl-minstrel to a Royal girl,
 When all the strange delightful whirl
Of life was full of joy and praise:

I sing Thee now with a full heart;
 Both having known life's change and loss,
 Both taken up its heavy cross,
Its bitterer and yet better part.

Womanliest Woman! queenliest Queen
 Thy country's Mother, as it sees
 Three generations round Thy knees,
And all that was and might have been.

O generous Heart, that, bleeding, fed
 Her people 'neath her sheltering wings,
 Taught pity for all suffering things
Out of the very breast that bled.

True, trusted, tried; gold thrice refined
 In the fierce fire that all doth prove —
 These fifty years of England's love
About Thy lonely bosom bind.

Live, blest with all that blessing brings,
 Die, full of peace and fruitful years,
 To live again in happier spheres,
The Crownèd of the King of kings.

THE QUEEN

I

HER ACCESSION

JUNE 20TH, 1837

IN this Jubilee year of 1887, how few comparatively of Her Majesty's present subjects can remember that June morning when we woke up in our nurseries, startled by the tolling of bells, and heard the half-comprehended news, "The King is dead," whispered about us. All that day there was a hush and awe about everybody; the shops were filled with people buying mourning, though not in any great sorrow: and then we were taken to the gloomy-looking church, where everything was draped in black, and everybody clad in black, to hear the funeral sermon of "Our Sailor King." Soon he was buried and forgotten; and all hearts turned to "Our Maiden Queen," "Our young and lovely Queen"—as the newspapers entitled her—whose coming of age, at eighteen, had only just been celebrated.

This was how the people felt. What must she have felt, that same June day, when she was roused at five

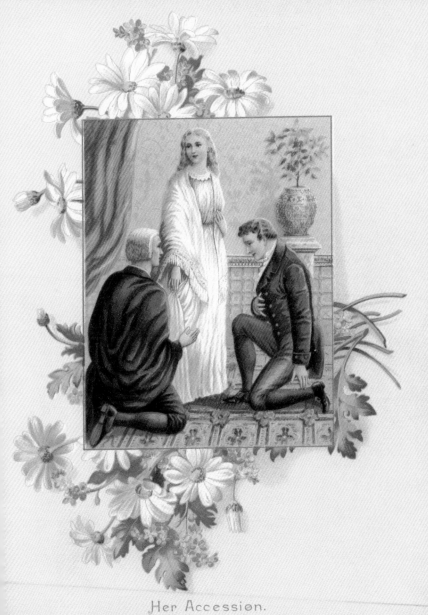

Her Accession.

in the morning—"out of a sweet sleep," the newspapers said—and came, with a dressing-gown thrown over her white night-gown, her pretty bare feet hastily thrust into slippers, her fair hair hanging over her shoulders, and her rosy face pale with emotion, to be told by the Primate, and the Lord Chamberlain (Lord Conyngham) that she was Queen of England? A picture unique in its pathos, simplicity, and solemnity, which deserves yet to be painted by some truly great artist, and to become one of the notable incidents of history.

We, the children then, the old folks of to-day, recall it with a tenderness incomprehensible to those who have only seen the elderly Lady, with her serious, often very sad face, which yet can brighten into a truly regal smile, as she drives past, bowing in answer to some loyal welcome, which especially pleases her: when the little boys and girls, who had probably expected a resplendent Being, with a crown on her head and a sceptre in her hand, say with amazement, "Is that the Queen?"

She is a Queen—right queenly; and has been, ever since that momentous summer morning, when her happy girlish sleep was broken by the tidings which ended girlhood for ever; when she gave up all the freedom, ease, and pleasantness of irresponsible youth to become the ruler and mother

of her people, and perhaps the hardest worker among them all.

Contemporary history says of her, referring to her first public act, the address to her Privy Council, on the afternoon of that same 20th June: "Her manner was composed, modest, and dignified; her voice firm and sweet; her reading beautiful. She took the necessary oaths, and received the official homage, without agitation or any kind of awkwardness." And so began her reign; a period which the experience of half a century has now entitled to be called—in imitation of, but far worthier than the Elizabethan—the Victorian Age.

II

HER CORONATION

JUNE 28TH, 1838

THE nation, after a year's experience of their young Queen, now prepared joyfully for her coronation. She was one of three girl-queens then reigning in Europe. The other two were Isabella of Spain, and Maria da Gloria of Portugal.

On that 28th of June, England was wild with excitement. Loyalty had for many years past been a sort of traditional duty—now it became a passion. In spite of all her arduous state labours, most conscientiously fulfilled, the Queen was a girl still. She liked to enjoy herself, to see and to be seen by her people at all those Royal ceremonials and entertainments, which no doubt soon cease to be any entertainment at all, and yet are an absolute necessity, if Princes wish to preserve the personal tie, and personal affection, between themselves and their people.

"It is the remarkable union of *naïveté*, kindness, and nature—i.e. *good* natur e—with propriety and dignity, which makes the Queen so admirable. She never ceases to be a Queen, and is always the most

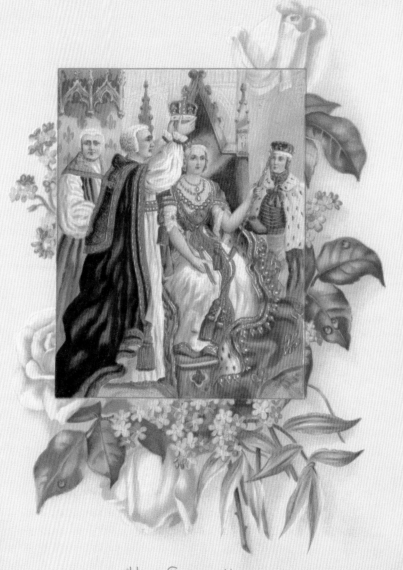

Her Coronation.

charming, cheerful, obliging, unaffected Queen in the world." So wrote Charles Greville.

The history of the Coronation-day is well known. From seven in the morning, Westminster Abbey was filled with an expectant multitude. "At twelve o'clock," wrote an eye-witness, "the Queen came in, gay as a lark, and looking like a girl on her birthday." But this mood soon changed into earnest feeling, even emotion. "She turned first very red, and then very pale, but controlled herself, and went through the ceremonies with grave composure." Not so those who looked on, for it is recorded that "most of the ladies cried."

In truth, at that time, most honest English eyes were wont to grow moist at the sight of Her Majesty. Whenever she appeared in State ceremonials, her extreme youth and small stature contrasted strongly with her tall, stout, elderly uncles and aunts; and her bright, happy expression awakened in all beholders a feeling of almost pathetic tenderness.

The Coronation-day was a "white" day through-out the land. Despite the enormous additional crowds which gathered in London, the festivities were marred by not a single accident. In the provinces it was the same. The present writer, then a child of twelve, recollects vividly how "all the world and his wife" turned out at earliest morning

into the merry streets: how bells were ringing and flags flying in the brilliant June sunshine: how the poor were not forgotten, and while there was a grand dinner in the Town Hall, and fireworks in the market-place, down the middle of every street were long white tables, decked with flowers and evergreens, where a plenteous tea was provided, gratis, for all who cared to sit down to it. And in every house people made merry, and spoke of "the Queen, God bless her!" as if she had been a child of their own.

Among the shouting crowds which lined the streets that day, there was scarce a man who would not have laid down his life for her, the dainty little woman, so pathetically young and sweet-looking, even if not exactly "lovely," as the newspapers persisted in calling her, who that day sat in St. Edward's Chair, and received the homage of all the great and good and wise of the nation.

So, placed upon the velvet throne, beneath which is the stone called the "Stone of Destiny"—which tradition declared was Jacob's pillow at Bethel! and credible history records to have been brought first to Ireland, then to Scotland, and finally removed by Edward I to Westminster Abbey—Victoria, by the Grace of God, Queen of Great Britain and Ireland, took upon her her final vows to her people.

III

HER MARRIAGE

FEBRUARY 10TH, 1840

THE turning-point in every woman's life, the event which makes her or mars her, be she peasant or queen, was anxiously watched for by the nation with regard to Her Majesty, now past her twentieth year, and still, as people loved to call her, "Our Maiden Queen." Elder folk hoped she would think twice before she married, and not be moved by any foolish, girlish fancy: younger ones trusted she would not allow herself to be made the victim of state policy, but would give her affections free play.

With the Queen's own private feelings, the wildest newspaper statements never dared to meddle. She had evidently a strong will, and a good courage of her own, not likely to be unduly influenced by anybody; and her right-minded dignity of demeanour left no loophole for the faintest breath of gossip. Her private life was very simple for a queen. She rose at eight, breakfasted alone, spent every morning in business duties: after luncheon, rode or drove, then amused herself with music and singing till dinner-time: spent the evening with her mother,

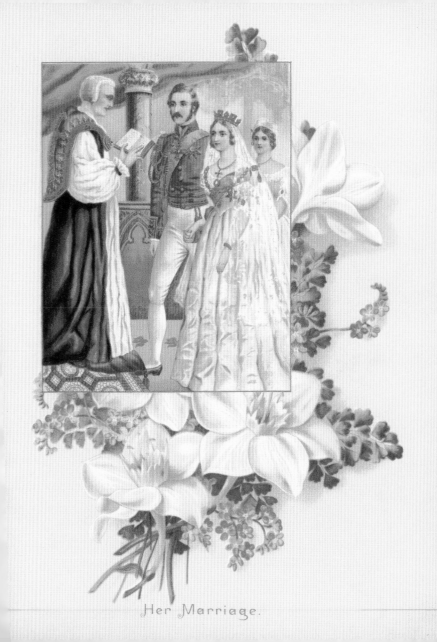

Her Marriage.

and the ladies and gentlemen of the Court: retiring early, not to sleep but to work.

Such was her ordinary life, continually busy, but as empty of incident as that of any other girl of her age, who walks "in maiden meditation, fancy free." So much so, that the nation, who kept a sharp eye upon every foreign guest who might be a possible suitor, was almost startled to hear that the Queen's chosen husband was Her Majesty's cousin, who had paid one unnoticed visit to this country, Prince Albert of Saxe-Coburg.

The country knew very little about him, except that he had a fine face and stately bearing; but the fact that it was a real old-fashioned "love affair," threw a romantic halo about the young Prince, and during the three brief months of the Royal engagement the enthusiastic public expended its feelings in numberless pictures, poems, and songs.

Thus the prudent elders, glad that our young Queen was married, and we younger ones that she had married for love, though also with the full approbation of those nearest and dearest to her, took the Prince upon trust, and rejoiced that Her Majesty should be happy, with the only true happiness that satisfies a woman's heart.

That she was so, no one doubted. In the midst of all her bridal splendour; with her magnificent

Honiton lace dress and veil—she was patriotic even in these trifles; with her twelve bridesmaids, chosen among the fairest of the British nobility, and most of them her personal friends, so far as a queen can have a friend—she was at the core a thorough woman. One who loved her dearly, Lady Lyttelton, writes thus, just after the wedding-day:—

"The Queen's look of confidence and comfort at the Prince, as they walked away together as man and wife, was very pleasing to see. It is such a new thing for her to dare to be unguarded in conversing with anybody, and with her frank and fearless nature, this restraint must have been most painful."

It was now removed. For the first time since her accession, she had an equal companion, a true friend as well as a husband; a heart, a young heart, against which she could rest her own; an intellect clear, trenchant, wide, and calm, which she could look up to as well as rely on, and a moral nature rarely beautiful, "wearing the white flower of a blameless life"—as he wore it unto the end.

IV

THE OLD DUKE AND THE LITTLE PRINCE

MOTHERHOOD had duly followed wifehood, to the great content of the nation. When, late in November, the Princess Royal was born, there was a slight sense of disappointment that she was only a girl; still, the succession was assured. When, a year after, the country rejoiced in a Prince of Wales, it felt itself entirely contented. After only twenty months of married life, the Queen was already the mother of two fine children.

"Albert brought in dearest little Pussy, in such a smart white merino dress, trimmed with blue, that mama has given her, and a pretty cap, and placed her on my bed, seating himself next to her, and she was very dear and good. And as my precious invaluable Albert sat there, and our little Love between us, I felt quite moved with happiness and gratitude to God ... I wonder very much what our little boy will be like. How fervent are my prayers to see him resemble his father in every respect, both in body and mind."

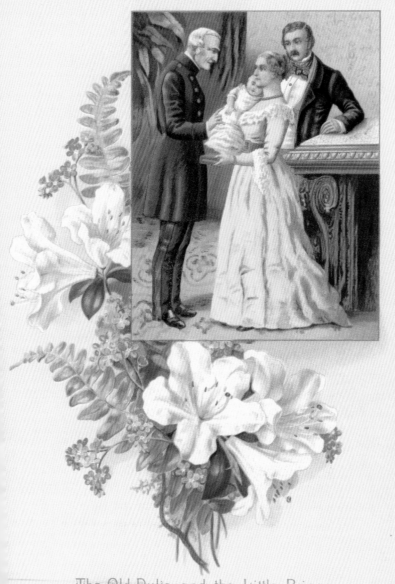

The Old Duke and the Little Prince.

Had the nation then really known the "noble father of our kings to be," how it would have responded to that prayer! But the Prince's silent sweetness, and total self-repression, sometimes caused him to be misunderstood by the public at large, which took to its heart at once the baby boy, and hoped to have what it had not had for centuries, a Prince of Wales whom it could thoroughly trust and approve.

Other children followed: the beloved Princess Alice, in life and death so like her father; Alfred, the Sailor Prince; two little girls, Helena and Louise; and then, one May morning, another little boy.

"After a rather restless night, which being *Walpurgis-nacht* was quite appropriate, he glided into the light of day, and was received by the sisters with *jubilates.* 'Now we are just as many as the days of the week,' was their cry, and then a bit of a struggle arose as to who should be 'Sunday.' Out of well-bred courtesy the honour was conceded to the new comer."

Thus wrote the happy father to his friend Baron Stockmar, and then explained that this May-day being the 81st birthday of the Duke of Wellington, by the Queen's and his own special wish, the old hero was to be godfather to the baby, who was named *Arthur* after him, and *Patrick* in remembrance of his country, which the Royal parents had lately visited.

Two and a half years after, on a dull November morning, the 18th—a day which none who saw it could ever forget—all London was astir in the dim dawn, and by daylight the long line of streets between Apsley House and St. Paul's were lined thick with human beings. Trafalgar Square especially was as smooth as a sea with tightly packed heads—only so motionless, except for an occasional roll, like a surge, and so strangely silent. Through it for hours, for the procession took so long a time to pass, was heard, following each after each, the shrill wail of the Dead March in Saul, the melancholy cry of Mendelssohn's Funeral March, and the deep solemn comfort of that finest of all, Beethoven's Funeral March of a Hero. England was burying the Great Duke, "with an Empire's lamentation."

His baby godson lives still, himself a soldier and married to a soldier's daughter, Princess Louise Margaret of Prussia. They have several children and a happy home.

V

THE GREAT EXHIBITION

MAY 1st, 1851

> "As though 'twere by a wizard's rod,
> A blazing arch of lucid glass
> Leaps like a fountain from the grass,
> To meet the sun."

SUCH was Thackeray's description of a sight which was like none others that have come after. Partly because it was the first. The extreme novelty of the idea, a great glass palace, with two tall elm trees imprisoned within it, where the birds flew about in the topmost branches, and sometimes even came down to drink at the fountain below, startled the public by its curious combination of nature and art, of use and pleasure. The enthusiasm it excited, and the myriads who visited it, made that May-day, and more than a hundred days after, one continuous festival.

As every one knows now, Prince Albert was at the heart of it all. His cultivated taste, his admirable business faculty, and great powers of organisation, to say nothing of his unwearied patience, and wise,

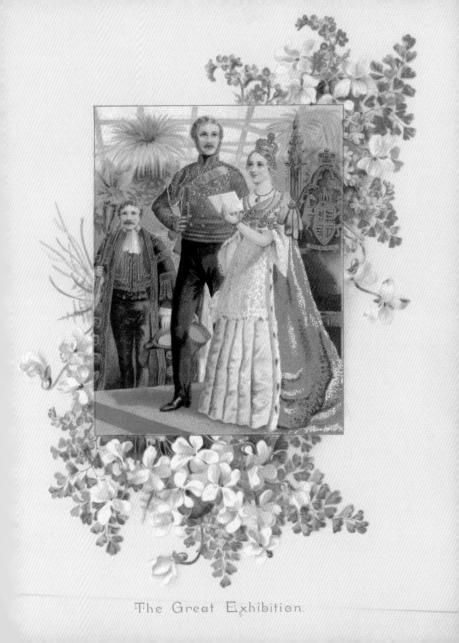

The Great Exhibition.

courteous tact, made him the pivot upon which everything turned. On April 30th, his Royal wife writes of him with anxious affection:—

"Everybody is occupied with the great day—to-morrow. My poor Albert is terribly fagged. All day long there was some question or other, some little difficulty or hitch; all of which Albert took with the greatest quiet and good temper. Great as is his triumph, he never says a word about it, but labours to the last, feeling quietly satisfied in the country's glory."

The outside glory of that momentous May-day all the world knows. Here is the under picture, given in the Queen's own words:—

"The first glimpse of the transept, the myriads of people filling the galleries and seats, the flourish of trumpets as we entered, gave us a sensation that I can never forget ... We went for a moment to a little side room, where we left our shawls, and then proceeded, Albert leading me, having Vicky at his hand, and Bertie holding mine. The sight ... was magical. One felt filled with devotion, the tremendous cheers, the joy expressed in every face, the immensity of the building . . . and my beloved husband, the author of this Peace Festival, which united the industry of all the nations of the earth—all this was moving indeed. It was a day to live for

ever. God bless my dearest Albert! God bless my dearest country, which has shown itself so great to-day!"

Rarely indeed is a national pageant so real in its emotion; a royal family so completely a family, and one at heart with the great family of the nation; which was now beginning to wake up to the fact that the Queen's husband was a powerful element therein, and had a voice which was used always for good. Though he held aloof from politics, all the true life of the land, as expressed in literature and its corresponding arts, in social science, in thoughtful acts of benevolence, felt his influence, consciously or unconsciously, to the core. It was so new for our Royal house, hitherto so stolidly Hanoverian, or if pursuing anything, pursuing mere pleasure, to interest itself in painting and music—to like the society of cultivated people—to have around it friends instead of flatterers. And the two whose perfect union was the most equal friendship, the most helpful, satisfied and satisfying love, were the young husband and wife, always seen together, in public and in private; never parted for a single day.

VI

THE QUEEN'S FAREWELL TO HER GUARDS

FEBRUARY, 1854

THE lovely Palace of Glass had scarcely melted away when ugly rumours began to circulate through Europe; prophecies of international quarrels, which were only too soon realised. Turkey—"The Sick Man," as, quoting some now-forgotten simile, it was called—afraid that the Russian Bear would pounce upon him, hug him to death and parcel out his bones, appealed for help to Western Europe, and England, France and Italy, responded to the call.

A calmer, if not wiser generation, looking back on the Crimean war, the first after thirty years of peace, may condemn it in its origin and still more in its carrying-out. But we who knew it, lived through it, can vouch for the sincerity with which it was begun.

There was an idea afloat that our army was going to protect a feeble country against a rapacious foe, and the chivalry of the thing touched the British heart. Battalion after battalion left our shores as gaily as children going off on a holiday, and as

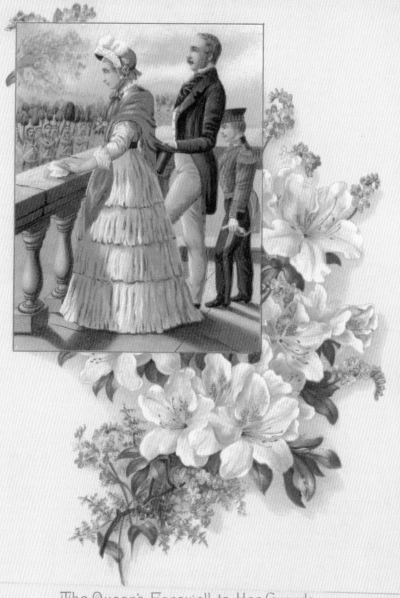

The Queen's Farewell to Her Guards.

careless. The Emperor Nicholas grew into a sort of ogre whom it was necessary to attack, and England felt herself a sort of Jack-the-Giant-killer for the good of Europe.

Whether we were right, and whether we gained anything, for ourselves or others, by the Crimean war, who shall say? Now, when the great enemy, who may not have been as black as he was painted, has been long in his grave, when his grand-daughter is our Queen's dear daughter-in-law, and his son and our Prince of Wales are brothers by marriage, it is difficult to remember how we once hated him—the terrible Czar of Russia, about whom no end of mythical stories were then told.

After all reasonable means had been taken to avert it, war was declared. Regiment after regiment marched through London, picked men, in the flower of their youth and strength, ready and eager to fight. The last that departed were the Scottish Fusiliers. Her Majesty, who herself rose in the dim dawn of the morning, to watch them from the balcony of Buckingham Palace, thus graphically describes the scene—in a letter to her uncle, King Leopold:—

"The morning fine, the sun shining over the towers of Westminster Abbey, and an immense crowd collected to see the fine men, cheering them as with difficulty they marched along. They formed

line, presented arms, and then cheered us very heartily, and went off cheering. It was a touching and beautiful sight—many sorrowing friends were there, and one saw the shake of many a hand. My best wishes and prayers will be with them all."

How many out of that "all" ever came home again!

After an anxious summer of slow inaction the war began. One sunshiny September day, crowds gathered at street-corners, reading eagerly the large-lettered bills, "Battle of the Alma," buying up every newspaper, seeking hungrily for all details. The public of to-day, sadly familiar with war, has no idea of the excitement of those days, when "Inkerman," "Balaclava," "Sebastapol," now mere historical words, were in our mouths continually; a vivid, agonising part of our daily life. There were endless tales of cruel sufferings nobly borne, especially by young officers, who in England had been the *jeunesse dorée* of society: of mismanagement equally cruel, and mistakes fatal as foolish. Throughout that bitter winter, and burning, deathly summer these stories came.

All that remains is the national feeling, expressed by the Queen herself in a letter she wrote to the widow of Sir George Cathcart—applicable to him and to how many more! "He died as he had lived, in the service of his Sovereign and his Country, an example to all who follow him."

VII

THE HIGHLAND HOME

1860

No human being can sustain itself, soul and body, through the hard work of life—harder still the higher the rank and consequently the wider the responsibility—without intervals of comparative rest. Sir James Clark, the Queen's physician, knew this, and advised Her Majesty to purchase a small castle on Dee-side, built by Lord Aberdeen's brother, Sir Robert Gordon, and make it into a permanent country home for the Royal Family; where, as the Queen wrote on first visiting it, "all seemed to breathe freedom and peace, to make one forget the world and its sad turmoils."

This was accomplished. Balmoral was first leased, then bought, by the Prince; a suitable house built, grounds laid out; and for twelve years the Queen, her Consort, and their children came there annually, making of it truly a Highland Home. State labours did not cease—for they must inevitably follow Her Majesty wherever she goes. She never knows, never can know, what we humbler folk call a complete holiday. But State entertainments and

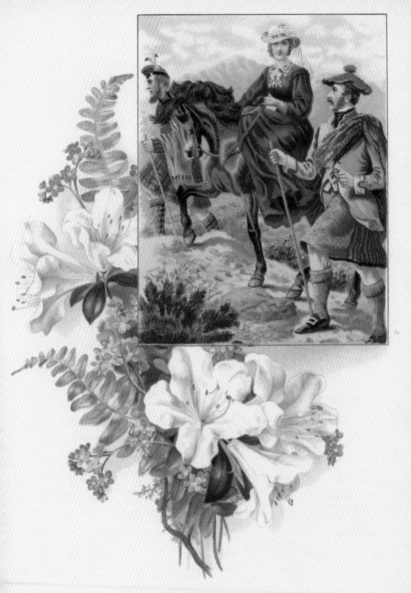

The Highland Home.

public appearances were temporarily put a stop to; State etiquette was thrown aside, and the Royal parents and children enjoyed themselves with the most intimate of their friends, just like any other family in the kingdom; more so than many families — from the simplicity of their tastes, and the warm attachment that existed among them all. The Prince went deer-stalking, of which he was extremely fond; he and the Queen climbed mountains together, had picnics in lovely glens, went into the shepherds' shealings, and talked with "auld wives," knew every tenant on their estate, and tried to make all their people there happy.

All this at no extra cost to the nation, for the Prince's clear head for business and wise practical economy enabled him to make the very best of the Royal income, for the benefit of many others besides the Royal Family. His improvements on the estate supplied work to all around it; and his prudent carefulness, much criticised at the time (the foolish world has a sneaking kindness for spendthrifts), resulted in a dignified comfort and ease. There were no debts to be paid. Beyond its fitting allowances to the Princes and Princesses, Her Majesty during all her long reign has never asked the country for a halfpenny. And if she asked for a little yearly rest, with her husband and children, of which the eldest

was herself already a wife and mother, in that peaceful Scottish hermitage, the nation did not grudge it.

Especially in the year 1860, which was a time full of political anxieties, and which may also be remembered as an especially wet and dreary summer, until the last week of August, when followed a September of unclouded beauty – such an autumn as is rarely seen even in the Highlands.

The Queen and Prince enjoyed it to the full. They had the year before ascended together Ben Muich Dhui, the highest mountain in Scotland: they did it again on August 24th, accompanied by their young daughters Helena and Louise, and attended by their faithful servants, Grant and Brown. The latter, who was his Royal Mistress's personal attendant, and whose rare devotion lasted as long as he lived, observed to the Queen, when the Prince walked on ahead, gaily conversing with Grant, "It's very pleasant to walk wi' a person who is always content."

"Always content" was the strong point in the Prince's disposition, and the permanent expression of his face. Though he now began to look older, the hair receding from, and the lines deepening on, his calm forehead.

VIII

DEATH IN THE PALACE

DECEMBER 14TH, 1861

IT is best not to dwell overmuch—it seems sacrilege almost to dwell at all—upon that last year when our Royal Family ceased to be a family; when its head and heart (social if not political) was taken away, leaving a widow and orphans, none the less desolate because their lot was cast in high places, where no creature could either help or comfort them.

The beginning of 1861 was marked by heavy public anxieties and domestic cares. The death of the Queen's mother, the excellent Duchess of Kent, almost the first grief she had ever known, struck Her Majesty to the very heart, and brought many additional labours upon the Prince Consort. His dear "Aunt-Mother," as he called her, left him her sole executor, and he alone could comfort and sustain the Queen in her sorrow.

No one can read the history of the last year of Prince Albert's life, so well and tenderly told by Sir Theodore Martin, without feeling that the illness of which he died must have been preceded by long months of weariness and physical suffering, never

BEN R. WILEY

August 13, 2007

Brian — Just the
briefest of notes to
thank you for all
your many kindnesses to
me, while I am in Cambridge
and while at home too. I
value our friendship very
much. Fondly, Ben

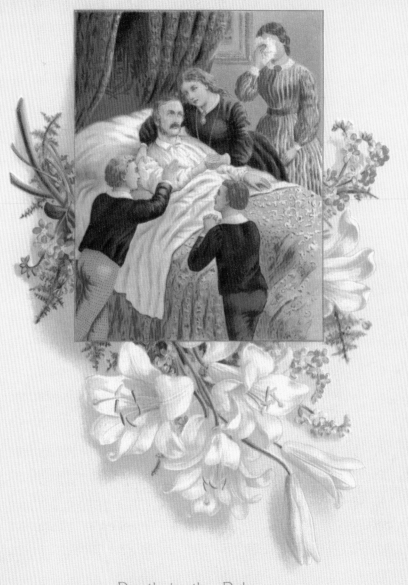

Death in the Palace.

complained of, and alluded to only in the most passing way. His strong, silent, self-devoted nature, anxious for others' good, never his own, and living for duty, not for pleasure, asserted itself to the end. The few words, "Weak and tired," "Felt ill and miserable," "No sleep of nights," &c., occurring rarely, oh, how rarely! in his journals or letters, show how for a long time he must have been what is called "breaking down," even though he had scarcely attained middle age. Length of life consists not in years, but in what is put into them.

A few weeks in autumn at Balmoral revived him, and then ensued the return to Windsor, with all the inevitable cares it involved. Domestic anxieties came in crowds—the illness of the Crown Princess of Prussia; typhoid fever, with two sad deaths, in the Portuguese Royal Family, which was allied to our own by the closest affection. All these things weighed down the already enfeebled strength of the Prince Consort.

He struggled against his illness to the last. Only a few weeks—nay, a few days before he died, we read of his taking a journey, in very bitter weather, to Cambridge, to see the Prince of Wales, returning early next morning; of his driving in pelting rain from Windsor to Sandhurst, to inspect improvements in the Military College there; of his walking in

a fur-lined coat, "still thoroughly miserable," to see the Eton College Volunteers; and finally of his persisting, Sunday, December 1st, on going to church, and "though looking very wretched and ill, going through all the kneeling." That night he went to his room, and quitted it no more.

Fourteen days he lingered, not in great pain, but in much weakness and suffering. Not long before he had said to the Queen, "I do not cling to life. If I knew those I loved were well-cared for, I should be ready to die tomorrow." "This spirit," the Queen wrote afterwards, "this beautiful, cheerful spirit, made him always happy, always contented ... He was ready to live, ready to die; 'not because I wish to be happier,' as he often remarked, but because he was ready to go. He did not do right for the sake of a reward hereafter, but, as he always said, 'because it was right.' "

To such a man death came, not as an enemy, but as a friend—never too early—never too late. It was the fit completion of a perfect life, as even those who lost him must have felt, or have learnt to feel now.

IX

SHE "WEEPS WITH THEM THAT WEEP"

THE nation was as patient with its Sovereign's bitter and for a long time inconsolable grief as it had been sympathetic with her joy—those twenty-one years of domestic happiness almost unparalleled in the history of Royal wives. It recognised that her loss was different from that of most widows. A Queen can have but one equal friend and companion—her husband; and hers was missing for ever from her side.

For many months, nay years, her broken heart shut itself up against all joy; but it could still understand sorrow. Scarcely a month after the death of the Prince Consort, when the newspapers were full of the terrible explosion at Hartley Colliery, which cost over two hundred lives, there was a telegram from the Queen conveying "her tenderest sympathy with the poor widows and mothers, and that her own misery only makes her feel the more for theirs."

It has become almost a proverb throughout the kingdom, that not an accident happens—public enough for general sympathy, not a death or

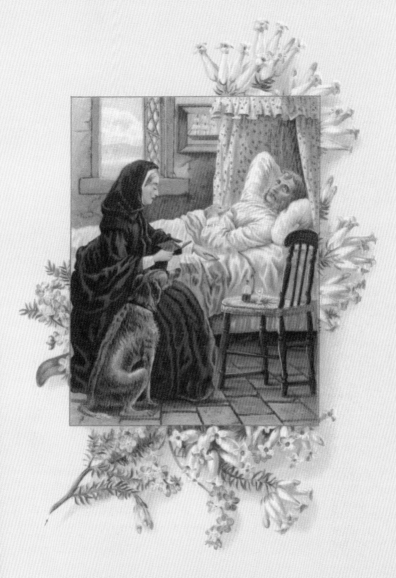

She "Weeps with Them that Weep".

misfortune to any one she knows—but a "Telegram from the Queen" is sure to follow. It would be a curious and pathetic chronicle how many widows she has visited in their affliction, from the Empress Eugénie down to the cottars of Balmoral; how many orphans she has written to; how many suffering souls of every rank have been comforted by the feeling that the Queen noticed and cared for their sorrows; and had a heart large enough to take in them all.

Dr. Norman Macleod, who, when the Queen was spending her first solitary birthday at Balmoral, preached before her on the duty of resignation, was sent for to her room. "She met me," he writes, "with an unutterably sad expression ... and began at once to speak about the Prince, his love, his cheerfulness; how he was everything to her. She said she never shut her eyes to trials, but liked to look them in the face; how she would never shrink from duty, but that all at present was done mechanically."

Still it was done; and she tried to find consolation in consoling others. Her face, absent from all State ceremonials, was yet known in many a cottage which sorrow had visited, both at Osborne and at Balmoral, whither, having given away her beloved daughter Alice, her help and stronghold, to Prince Louis of Hesse, she went, in July, 1862; but, as she herself writes, found "no pleasure—no joy—all dead."

Yet still the Queen did her duty, like a queen. It was 1864 before she had any State receptions, but long ere then she came forward publicly in many works of mercy.

As early as 1863 she and the Princess Alice visited the Military Hospital at Netley. Some years before she had laid the foundation stone of it, Prince Albert, as ever, at her side, and written thus: "Loving my dear brave army as I do, and having seen so many of my poor sick and wounded soldiers, I shall watch over this work with maternal anxiety."

And almost like a mother, the Royal widow, who came quite privately, after having regarded the foundation stone with much emotion, walked round the miles of hospital wards—the galleries being a quarter of a mile in length; and when it was proposed to her to omit one of them, answered: "No; the poor men would be disappointed if I did not go to them." In one ward an old soldier from India lay dying. The Queen spoke to him, and he answered, "Thank God for having let me live long enough to see your Majesty with my own eyes." And wherever she passed, the poor, sick faces brightened at the sight of her.

And thus—though it was difficult to "rejoice with them that do rejoice," and yet she did it sometimes, as at the marriage of the Prince of Wales with the Princess Alexandra of Denmark—the Queen never failed to "weep with them that weep."

X

CONSTITUTIONAL CRISIS

1868

A CONSTITUTIONAL Monarchy must always have had its crises, which, if difficult and trying to the people, are equally so to the Sovereign. The Queen of England is no Sultan, attended by an obsequious vizier, removable at pleasure; no autocrat of all the Russias, whose mere word is a national edict. She is the free ruler of a free country, who abides by its laws as implicitly and conscientiously as any of her subjects. To her, however, every change of ministry must necessarily involve much more than it does to them—the disruption of personal associations, the breaking of business ties—a thing never very pleasant to anybody.

Whatever be Her Majesty's private opinions, and the experience of fifty years of government, added to a naturally strong character, must by this time have given her very decided opinions of her own, she has never allowed them to appear, or to interfere in any way with the absolute impartiality of a sovereign, who rules not only by hereditary right and "the grace of God," but by the will of the nation. Every

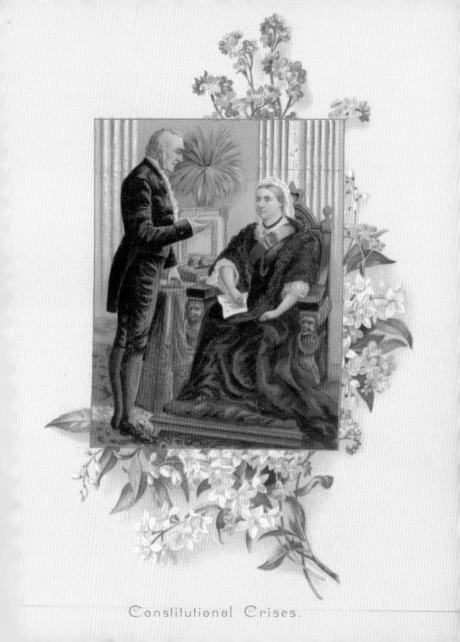

Constitutional Crises.

new cabinet, every modification of men and measures which was deemed expedient for the good of the country, she has always accepted with a dignified reticence, and a rigid conformity to all the laws and customs of what we call a limited monarchy; under which, while other thrones have been shaken, or have crumbled into dust, ours has stood secure. How much of this has been due to the personal character of the monarch history will record.

And how much the Queen must have seen!—how many historical personages she must have known during this half-century! Even the list of names of her successive Prime Ministers is a chapter in English history, to the new generation mere history, but to her it must be a living present; Lord Melbourne, who guided the young Queen in her first Cabinet Councils, and rode with her down the Long Walk, at Windsor; when, it was recorded, the merry girl of eighteen rode so fast that the elderly gentleman of sixty found it hard work to keep up with her! Sir Robert Peel, the stately, cultivated, yet partially self-made gentleman: Lord Derby, the aristocrat, *pur et simple*, true to all the traditions of his race: Lord Aberdeen, whom even his opponents held to be "a man of wisdom and rectitude:" Lord John Russell—"Little Johnny"—butt of *Punch* and

other caricaturists, but universally liked and respected: Lord Palmerston, long remarkable for his extraordinary youthfulness of appearance and manner—a vitality which never flagged till the old man of eighty-one startled the country by suddenly dying—one of the few Premiers who has ever died in harness.

The *Court Circular* of December 5th, 1868, records that "in obedience to a summons conveyed to Hawarden by General Grey, Mr. Gladstone proceeded to Windsor and had an audience of Her Majesty in the afternoon," which resulted in his accepting for the first time the Premiership resigned by Benjamin Disraeli. From that date the political history of England is a kind of see-saw between these two great rivals.

It has been alleged, in explanation of the fact that countries often flourish more under queens than kings, that a man is usually led by a woman, whereas a woman listens to the good advice of a man—and we all know now what kind of man it was who for twenty-one years guided our Victoria. But, as the nation has proved since his death—and as history has again and again recorded—of this fact there can be no doubt, that no kingdom is happier and safer than when its sceptre is in the hands of a wise and good woman.

XI

PEACE WITH HONOUR

1878

EVERY Englishman, whatever be his personal opinion of either or both, will allow that the two most prominent political figures of this generation have been William Ewart Gladstone and Benjamin Disraeli. In the earlier time, Pitt and Fox are their nearest historical parallel; but with them the arena of combat was far narrower, the battle less complicated, and the struggle lasting far less long; since both died at a time of life when our two veterans, full of years and honours, were fighting still.

The contest was at its height, when, Fate having turned the tables and made Mr. Disraeli Earl of Beaconsfield as well as Prime Minister, he took his memorable journey to settle the affairs of Europe at Berlin, in conjunction with all the greatest statesmen of the period, and brought back thence to his Royal mistress the message, which has grown into a proverb, of "Peace with Honour."

At the time it created the greatest excitement. The sayings and doings, real or imaginary, of the Congress of Berlin were in everybody's mouth. What

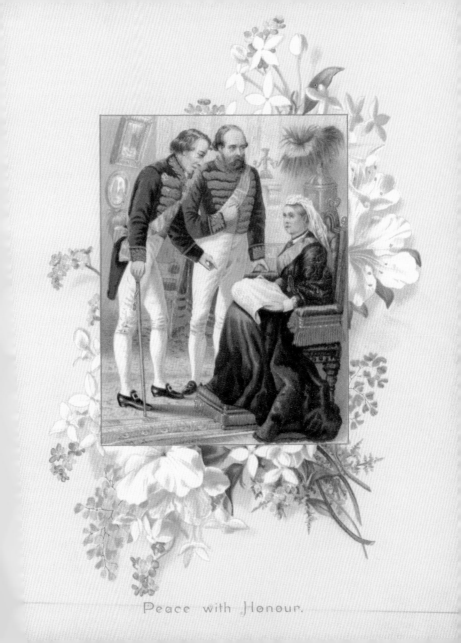

Peace with Honour.

Prince Gortschakoff looked like; when, if ever, Prince Bismarck smiled, and so on and so on, were minutely reported. Especially did the public dwell upon the proceedings of Lord Beaconsfield, how the German Police had insisted on his being "protected" everywhere, till at last, declaring that he preferred assassination to *surveillance*, he boldly marched through the streets alone, watched with amusement by many a respectable Berliner, who had probably never had the slightest intention of harming him.

Many of our young men and maidens of to-day will remember being taken as children to see the return of Lord Beaconsfield and Lord Salisbury to England, on July 15th, when they made a triumphal entry into London; how Trafalgar Square was packed with a dense throng, the ill-off part of which amused itself by squabbles with policemen, eyeing with equal interest the fainting of a woman, and the collaring of a pickpocket; while the well-off portion of the crowd lounged at windows, and on balconies, or consoled itself with sherry and sandwiches. There was no particular enthusiasm; and very few understood clearly what they had come for; but it was a crowd, and that was enough.

And when there appeared the climax of the sight—two gentlemen, one old, the other middle-aged, and two ladies, in an open carriage, bowing

with all their might, the crowd shouted with all its might, as in duty bound. The carriage drove by, the hero of the day being seen by some and guessed at by the rest; the crowd filled in after it and followed it for a little, then melted away, in the sudden fashion in which London crowds do gather and melt, and all was over.

Another show, not shared in by the general public, was the Queen's reception of her successful plenipotentiaries at Osborne, when, on July 22nd and 30th, she invested each—Lord Salisbury, it was said, at the special request of Lord Beaconsfield—with the Riband of the Garter; an honour only bestowed for distinguished services, or given to the highest of the nobility.

There could hardly have been two more opposite types of men than the two who now received it. The shrewd old diplomatist, who had made both himself and his money, except what he owed to his generous and affectionate wife, whose devotion he repaid by life-long respect and tenderness; the brilliant Anglo-Jew, who yet had always a kind word and a helping hand for the ancient race whose faith he had abjured; and on the other side the nobleman, thoroughly English, aristocratic to the core, counting his ancestors back to Shakespeare's "My Lord of Salisbury."

XII

THE COLONIAL EXHIBITION

THIRTY-FIVE years had gone by since the bright May morning when the Queen, in the zenith of her happiness, opened the Great Exhibition of '51. The few, very few, now remaining of the Court who had seen her then, standing with her young husband by her side, holding by the hand little "Vicky" and "Bertie" must have felt an involuntary choke in the throat as they watched Her Majesty when she opened the Colonial Exhibition.

The newspapers gave brilliant accounts of this gorgeous spectacle, but eye-witnesses describe it as being most touching. The Queen stood, with six out of seven of her surviving children round her, with sons and daughters-in-law, and several of her grandchildren— a truly family group, greeted by the vast multitude there assembled with a family welcome. And when after the Prince of Wales had read the address and the Queen had replied, the son kissed his mother's hand, and she drawing him towards her, kissed his cheek, the humanness of the action went to the very hearts of the Colonials. They

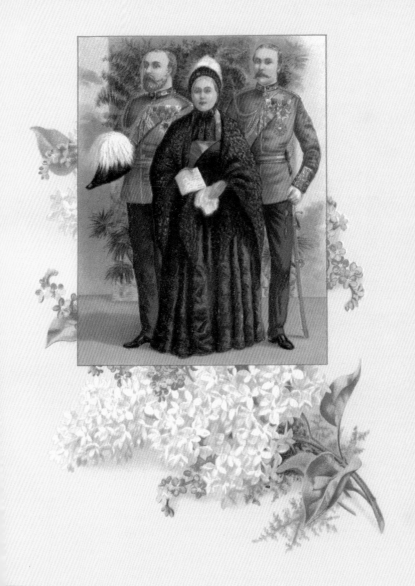

The Colonial Exhibition.

set up a ringing cheer, the memory of which they will carry with them to the ends of the earth, and the end of their days.

The English audience were not behindhand. In her long twenty-five years of widowhood they have so seldom seen their Queen's face at any public ceremonial, that now they had her it seemed as if they could not make enough of her. Her Majesty responded with hearty good-will, and appeared thoroughly to enjoy herself, beating time to the music; at each verse of the Ode—Tennyson's and Sullivan's—worthy of both—turning round to bow and smile at the singers, and even clapping her hands with innocent pleasure, and an expression of content that the public had not seen for years. Whatever she felt, and she could not but have felt keenly, she controlled it all; and the vast assemblage beheld in the woman of sixty-seven, sorely tried—having gone through almost every joy and sorrow that a woman can know—the same spirit that shone in the face of the Girl-Queen of eighteen—the same affectionate trust in her people—the same unselfish delight in the happiness of others—the same quick sympathy in all things lovely and all things good.

When the last sounds of the Hallelujah Chorus died away, and the clear pathetic voice of the Canadian, Madame Albani, rang through the hall in

the first notes of "Home, Sweet Home," there must have been few eyes there gazing that were not slightly dim; and few hearts that did not feel how among all the upheaving and down-falling of nations the whole group standing there whom we are accustomed to call "Our Royal Family" are still a family; honourable, estimable, and united; and that the mother of them was also the Mother of the land.

And though their father was not there, though among the twelve thousand souls which filled the Hall that bears his name very few could ever have seen his face, still his influence was as strong as ever. Every year England finds out more and more what she owed during those too-brief twenty-one years—in the arts, in commerce, in wise and benevolent enterprises, and above all as a perpetual example of high thinking and right doing, to him, whom not only his nearest and dearest, but the world at large, now know as "The great and good Prince Albert." *Albrecht*—all bright—was his name; and all bright is his beloved memory.

XIII

FOUR GENERATIONS

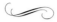

OF the Queen's fifty-three descendants forty-four are still living, viz. seven children, thirty-one grand-children, and six great-grandchildren. Her lost son and daughter, Princess Alice and Prince Leopold, have both left offspring, in whom their own excellence may reappear. Of the Queen's dead grandchildren, a very small number out of so large a family, the memory is affectionately preserved by a tablet put up in the private chapel at Windsor. The Sovereign of a kingdom that stretches half over the world has a woman's heart—it never forgets.

This group of four generations includes the Queen, Princess Beatrice and her infant son, Prince William of Prussia, grandson of the Crown Princess, once our Princess Royal, and Princess Alice of Battenberg, granddaughter of our well-beloved Princess Alice. Victoria, Albert, Alice—the names are now continually repeating themselves in new generations, and the fifty years that we have been familiar with them seem to have gone by like "a dream when one awaketh." It is difficult to realise that we are the same, we who were young when she

Four Generations.

too was young—the Royal mother, grandmother, and great-grandmother, who will carry down to far distant generations the influence of her life.

It is not likely that the future reign, or many reigns to come, will have another Jubilee. In all human probability—God grant it!—the next head that wears the crown will be already an old man's head. And many a century may pass before England sees such another fifty years, so full of steady improvement, and, despite all that pessimists may say, going on improving.

We who remember it, who have lived through it, may be pardoned if we feel, more strongly even than the present generation, all that it has been and all that the Queen has helped to make it. Our heads have grown grey with that on which has rested the British crown—not always as light as a wreath of roses. If English loyalty, once more than a sentiment, a devotion, has somewhat calmed down, as those who first felt it have one after the other gone to their rest; if "our young and lovely Queen" has become a woman fast growing old, and needing helpful tenderness in bearing, as she does bear so bravely, the heavy burthen of the State—it is the more reason for putting forward in this Jubilee Year all that she was and has been, as well as all that she is. The plain facts speak for themselves, without any

foolish adulation of the Sovereign merely as a Sovereign.

The world—at least, the civilised and Christian-ised half of it—has ceased to believe in the Divine right of kings. It recognises that the highest right of any man to be a ruler lies in his capacity for ruling, and the way he rules. But it will never cease to reverence that kingship, or queenship, "by the grace of God," which proves that it has the grace of God by possessing sweet human graces, and by showing throughout a whole lifetime, as our Victoria has done, that to be a true man or woman is the Royalist thing on earth.

FINIS